illinois state university

university galleries

college of fine arts

110 center for the visual arts
campus box 5600
normal, il 61790-5600
tel 309.438.5487
www.cfa.ilstu.edu/galleries
gallery@ilstu.edu

Sid Sachs
The University of the Arts
333 South Broad Street
Philadelphia, PA 19102

Enclosed please find a complimentary copy of Stephanie Brooks' *Poems and Poem Forms*. Brooks designed the book in conjunction with her solo exhibition, *Distance Intimacy*, presented at University Galleries from February 24 through April 5, 2009.

Sincerely,

Kendra Paitz, Curator

Stephanie Brooks
Poems
and
Poem Forms

with an essay by Rachel Furnari

Heart-Shaped Metaphor

Abstraction: Form

To write about abstraction in reference to Stephanie Brooks is not to invoke a heroic, pure abstraction rooted in the historical avant-garde and promises of spiritual transcendence. It also isn't a negation, as in Ad Reinhardt's 1962 hope that abstraction would mean "no lines or imaginings, no shapes or composings or representings, no visions or sensations or impulses, no symbols or signs or impastos, no decoratings or colorings or picturings, no pleasures or pains, […] no things, no ideas, no relations, no attributes." Mid-twentieth century iconoclastic, mute abstraction is countered in Brooks's art by her insistence on an affective language that continually demands the reciprocity of the viewer in a way that Reinhardt rejects. Her objects that include declaratory statements in the first person, as well as those with interrogatives directed at an unspecified "You," present abstraction as a conversation and language as a physical material of exchange. This is abstraction after its daring *coup d'état* of the 1950s and 60s: a post-abstraction that is later, but never past; an abstraction whose forms have become intimate and relational. This leads to a destabilized representation of affect where issues of distance, identification, narrativity and form are always competing.

Form is one of the most obvious ways to talk about Brooks's art. Her work is saturated by the concept both as a noun and a verb. A look at the Oxford English Dictionary definition reveals *form* to be: n. *Shape, arrangement of parts; The visible aspect of a thing; An image, representation, or likeness; The essential determinant principle of a thing; A set, customary, or prescribed way of doing anything; A set method of procedure;* v. trans. *To give form or shape to; To arrange; To construct, frame; To be the components or material of.* All of these variations are visible in Brooks's adaptation of ordinary forms: tax forms, office objects, poems, institutional signage, proofreader's marks, diagrams, charts, exercise manuals, portraiture, family snapshots, crayons, and the *OED* itself. As a formalist, the dictionary would also tell us that Brooks's attachment to these forms is strict and excessive. Fortunately, she is always disturbing their identities, resulting in the re-imagination, exhaustion or exposure of our affective investments in the form under analysis.

In this way, Brooks is somewhat less concerned with form as convention, and more with form as syntactical structure—the rules that make up a given formal system. When a form, such as a building's directory, has been abstracted, she ends up with a representation that makes manifest the form's syntax (in the building's directory a list of floor numbers followed by possible destinations) but not its expressive content, which she is then free to work within, modifying and substituting (e.g., "freshly cut grass" instead of "Office of the Mayor"). As Sol LeWitt wrote, "the form becomes the grammar." Although Brooks may use abstraction as concealment, unlike this Conceptualist, her reduction of the basic grammar of ordinary forms is never a means to evade subjectivity or artistic intention.

Minimalism: Intimacy

When Donald Judd wrote "Specific Objects" in 1964, he was constructing a categorical identity for a new kind of three-dimensional object—not sculpture, not painting—that we now associate with Minimalism. Of crucial importance to Judd was the experience of "real" space in contrast to the illusionistic space of representational painting and sculpture. In 1966, Robert Morris followed this inaugural text with "Notes on Sculpture I-II," in which the sculptural value of scale became paramount for "one's awareness of oneself in existing in the same space as the work." Morris rejects the "monumental" moniker, but insists on size as a guarantor of the public quality of this new three-dimensional work. Critically, he espoused distance and explicitly rejected "intimacy-producing relations"—to be pulled into an intimate relation with an object is to be pulled away from the space in which the object exists.

It is precisely these intimate relations that characterize Brooks's minimalism—an intimacy that is driven not only by her subject, but also by her objects' sizes. Though "private" may be an adjective relevant to Brooks and disdained by Morris, "privacy" is not. Her sources are almost always public forms of transaction and exchange, even when they are indicative of psychological interiority. Her morphometric transformation of famous love poems into wooden blocks is a reduction that maintains many Minimalist ideals. Brooks adapts Morris's favorite morpheme, the cube, to accommodate the shape of the poems while refusing their ambiguous emotional content. The love poems move from an experience of uncertainty, disaster, exuberance, belonging and metaphor to one of shape, light and the apprehension of space: the specific space they occupy in relationship

to our bodies and the symbolic space of the love poem itself. This ordering of the disorderly set of fantasies and emotional bargains[1] that the love poem represents does not constitute an emptying since it does not, as Morris would have it, defeat its form. Rather, it is recomposed as a singular unit, in this case a shape, in another case, a single letter or sound.

This emphasis on the complicity between object and beholder, on the conventions and expectations of ordinary forms, alienated and frustrated some of Judd's and Morris's contemporaries. These complaints, cataloged famously in Michael Fried's essay, "Art and Objecthood," actually bring into relief one of the most interesting features of Brooks's engagement with the Minimalist project: the persistence of time. One of Fried's problems with Morris was his claim that "the experience of the work necessarily exists in time." This was in contradistinction to the modernist experience, defined by Fried as a lack of duration, "amounting, as it were, to the perpetual creation of itself, that one experiences as a kind of instantaneousness: as though if only one were infinitely more acute, a single infinitely brief instant would be long enough [...] to experience the work in all its depth and fullness, to be forever convinced by it." In a Minimalist vein, Brooks's work is not apprehended instantaneously, it is a temporal experience: of the time it takes to read; the duration of rhythm and musical scores; and of the interpellations that produce us as the subjects of her work ("I love you." "Don't fuck with me." "You're a Fuck-Up."). In fact, Fried describes the manifestation of temporality in Minimalism as an expression of the "expectation, dread, anxiety, presentiment, memory, [and] nostalgia," that arise in the ongoing moments of an aesthetic experience—bad feelings for the modernist art critic and emotional incident the Minimalists would reject, but very characteristic of the affective circularity of Brooks's art.

Sentimentality: Resistance

While intimacy names (at least the hope for) a shared moment or space of understanding, recognition, and mutual acknowledgement, sentimentality is often a name for something more monstrous. Associated with femininity and feminine cultural genres like chick flicks, sentimentality is shorthand for disproportionate feeling, insincerity, and an abandonment of reason. Yet for Brooks, the sentimental and the intimate are means of relating that take place in public as well as private, in the ordinariness of our daily lives: sensible in offices and homes, in familiar stock phrases, on the

street, and in weather reports. It is the experience of affective ambivalence toward our own lives and precarious sense of belonging that Brooks so ably captures when she uses sentimental forms such as hearts, poems, and family photos. Her series "Photos" consists of zinc plates hung in squares, each etched with a short description of a mundane and ubiquitous subject: "birthday cake and smiling teenager," "Mom," "Atlantic seashore/on a clear day/in New England," and "three old friends." Abstracting a sentimental form such as the family snapshot to its physical conventions, while still leaving space for—in fact demanding—the specificity of the viewer's own self-insertion, is emblematic of Brooks's work. In front of these photo groupings it is difficult to feel either easy sentimentality ("My mother is beautiful." "I love my mother.") or cynical distance (a reflection on the violence and disavowal that the picture of my mother represents, e.g., "My mother never took care of me."). The artist's commitment to the original form of the object, be it love poem or photograph, resists the predictable emotional performance of romantic or familial love which the sentimental usually requires from the viewer. Brooks continuously inhabits and literalizes the intimate scale of the sentimental while resisting its simplifying arrangement of memory and desire.

1. See Lauren Berlant, *The Female Complaint: The Unfinished Business of Sentimentality in American Culture* (Durham, NC: Duke University Press, 2008).

Love Poems

Exclamation!
Longing,
longing.

Nautical metaphor.

Exclamation,
exclamation,
very sexy sexual innuendo.

Rejection of one metaphor
then another,
then another.

Declaration of love
describing an abstract place.

Botanical simile.

Explanation of gratitude for requited feelings,
contemplation on the boundaries of love.

Expression of physical intimacy
describing the ways in which
two people may occupy one space.

Simile,
simile,
simile.

Declaration of love.

Description of love's intensity
using the chemical properties
of evaporation and melting point.

Description of affection's duration over time.
Parting words.
A promise to return
with an abstracted approximation
of time and distance.

Flashback:

Detailed description
of a place,
of a moment shared,
and
an erotic kiss.

Flash forward:

Unabashed desire.
Longing,
longing,
longing.
Request for affection.
Context.
Meteorological metaphor.

Astrological metaphor.
Compliment,
compliment,
compliment,
compliment,
compliment,
compliment.
Wish fulfillment, wish fulfillment.

Simile,
simile,
simile.
Metaphor,
metaphor.
Declaration,
compliment.

Rhetorical question.
Inventory list
Of the ways in which affections
May be quantified:
1. volume
2. distance
3. height
4. time
5. adverb
6. adverb
7. dichotomization
8. emotion
And in conclusion, a glimpse of the afterlife.

Statement of mutual affection.
Fire simile.
Ceramics metaphor
continued,
continued,
continued,
continued.
Textile metaphor,
death metaphor.

My Favorite Poems

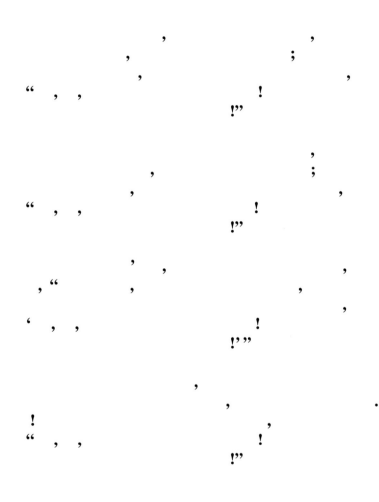

,

?

?

, ;

, ,

.

,

.

,

.

, ,

.

.

.

.

.

- .

Distance Intimacy Sonnets: Email Sign-offs from a Break-Up

I want to be kissing you, legs entwined with you, talking in whispers and
small voices with you.
Hundreds of little impressions, qualities, gestures, phrases, laughs, touches
from last night
Keep floating past, slowly, long enough for me to spend some time with each.
There's an impetuous part of myself who doesn't understand why you can't be
Sleeping here tonight.
Talk to you tomorrow,
Get over here!
My body keeps talking to me about you,
How lovely!
See you soon,
I totally miss you!
My heart feels enormous and happy when I think about you.
How's about I come to your place tonight?
Soon.

I miss you,

I'm sorry.

My little day wants to entwine its legs with your little day,

I wish I were working across this table from you.

Peeplove,

It's really, really nice having you on the other end of this tin can.

Yours,

Jogging? Wrestling? Greased wrestling?!?

Hi you. I'm feeling all happy and liquid thinking about you.

Sending telepathic sweet nothings. And some select sweet somethings.

Are you thinking about rolling around in bed, bare legs entwined? i am.

So yours,

I sneak down into your office and garden and bed 1000 times a day,

 in my mind.

Soon,

Yours,

How to quantify how much I want to kiss you right now?

Soon,

Thousands of varieties of affection to you,

You're lovely. I miss you too.

I wish I were crawling into bed with you right now.

My burritos are ready.

Hope you're having a fun lunch with LB.

See you soon!

Yours!

I miss you. I heart you.

Yours,

Self-flagellatively, but revving up for some homespun endearing son-art,

See you soon.

Thoughts in your direction,
Oh...
I really, really want to make out with you right now.
Thank you!
Good night You,
[black gathering cloud],
Rad! thank you!
!!!,
There should be a portal from my room to yours, I'm thinking.
I feel like being near you.
Can't wait.
Does that work?
I figure it's measurable.
I'm laughing the kind of laughter that makes me want to bury my head in your
 neck.

Yours!
Yours,
Good night lovely,
I wonder what you're dreaming about.
V. v. yours!
Miss you something fierce.
I heart you peepmost!
Complicated math.
I liked the constraints too.
Woop,
I literally can't wait to be back in bed with you. I'm excited about lots of things
in between too.
I'll see you tomorrow (which is not soon enough),
Sigh.
In my imagination, I'm nuzzling your neck. Possibly falling asleep there.

Blah!
Yours!
Talk soon,
Insignificant nothings from up north, whispered as close to your ear as I can get
 them,
I'M SORRY I'M SHOUTING. It's the most affectionate kind of shouting.
I'll talk to you tomorrow,
Soon soon,
Yours!
Yours!
Until tomorrow,
Fuckin' 'ell I miss you.
Hearts in eyes,
Love.
Love!

Yours,
Love,
Yours,
Soonsoonsoon,
Soon soon soon,
On my way!
God I really love being with you.
Love,
Soon,
Soon soon,
Ahhh.
Yours,
Love.
I love you!

Love,
Love,
Love,
Yours!
Greedily,
Love,
Love,
Love,
Hearts and birds floating around head,
Love,
Love,
Love,
See you soon,
Smooch.

LOVE!
To summer!
I love you!!! God, you're the best!
I heart you! Thank you so much. Holy crap. I'm slightly overwhelmed.
I LOVE YOU.
Good luck with the chunk.
Big enfolding love to you!
Roar,
Love,
I want you. I want you, period.
Stick with me!
Yay!
Love!
I love you...

Love,
Love,
LOVE
LOVE
For a slow afternoon,
See you soon,
Love!
Lick,
Love,
Happy afternooning,
UNBELIEVABLE!
LOVE!
I LOVE you.
I miss you. a lot.

I LOVE YOU.
Love,
I love you.
You can't imagine what it does to me to hear your voice.
The message you left for me yesterday re-starts my stalled heart.
Love!
Yours in near-real-time-communication,
You're beautiful.
Love,
Lick,
!
WHY aren't you still here?
Fever pitch fantasy is rising.
Love.

[heart]
Con amor,
I miss you.
Yours!
I love you.
Talk to you soon.
Love,
Good morning!
With love,
Love,
Yours,
Love,
I love you.
See you soon.

L,

I LOVE YOU. (I was thinking that so loudly on my way in this morning).
It's so nice to settle in by your side. I like it there. Although I also feel it
When we're not physically side by side.
I hope you're ok.
Love in your direction,
Love,
See you soon.
See you in a minute.
Love,
Good night,
Hearts in eyes,
Soon, right?
My body is aching for yours.

Soon, right?
You're getting a chest bump for that later!
I'm really glad you're coming to dinner on Wed.!
Love,
Hearts all over body,
Sigh. yes.
It's about Augustine, and grace, and god, and the beauty of the soul.
I also like the idea of living inside ANY of your fantasies.
L,
Strip off your clothes and run naked through the backyard!!!
Rest. Feel better!
Talk to you in a min,
Two great big hoorays! Some pom-pom waving. A big human pyramid
With me leaping from the top. In pig tails!

See you soon.
Love,
I love you.
I love you.
Wist,
Your meathead,
Love,
Love,
Thank you!
Love!
Love.
Smittenly yours,
Love,
Woohoo!

Love,
I MISS YOU.
Talk to you soon,
Biggest love,
This weekend was so nice. Comfy, fun, and super-sexy!
Love,
Sheesh.
I love you.
Yours,
[hearts in eyes]
Love,
Good lovin',
1...2...3...GO!
I LOVE YOU. Largely.

Love,
Hubba hubba.
Your ringing prose makes my loins stir. And I don't mean that metaphorically.
Good morning!
Love,
Affection to you,
Word!
Good night superlover,
Love,
Peep-out,
Yours,
Love,
How are you?
THANK YOU!

[fist pump]
Missing you,
Love,
Yours is 3-4-4-3-3-4.
Love,
Love,
Love,
Happy birthday. I love you.
Thunderous love,
Love,
Love,
Love,
...
Love.

Love,
Love,
Help...
Oh no,
We're doomed.
L,
Love,
I can't quite see where all this fear and reclusiveness are coming from.
Man, this is a WEIRD time in my life.
Fucking hell!
Amazing.
I'm sorry.
Here I come.
Yep...

Last night felt like the first of the many talks we should have had three years ago
When we were breaking up.
Love, solidarity.
I feel a little lost.
Love,
Efficiently,
Love,
Love,
I hope you're doing ok. You seemed slightly distraught before.
Love,
I couldn't believe you smiled when you saw me the first time today. That meant a
 lot to me.
Love,
I guess I'm working on it.
I'm sorry I've hurt you.

Page 35

Why not
invite
the past
out of its fields?

Page 36

We dispute and hate the truth
only as
confusion of thought.

Page 37

From heavenly touches:
the sublime!
Stars appear.

Page 38

Charming poet,
Speak truly of the heart.

Wild delight runs through me,
in my thoughts of a man.

Page 39

bare,
transparent,
and
uncontained.

i produce
a
necessary
melancholy laboring under contempt.

Page 40

Our senses,
like childish delight:

Angels/beasts at play.

Page 41

The wind waits for the diminished friction of man,
like an aggregate of the world changed.

But there is no obvious good.

Page 42

Plastic integrates the landscape—
so foul, and
sort of,
(almost)
agreeable.

Page 43

I see the spectacle of the sunrise:

ridiculous dawn—
reform me!

Page 44

The attentive expression,
like purple and gold tinsel:

It shines!

Page 45

O graceful, heroic, rational creature!

All virtue is under the shadow
of the purple mountains of great deeds.

Page 46

So glorious—
sitting by his side,
arms embrace,
happy.

(How easily he took with him
the day
and became a thought.)

Page 47

Does all good delight?

This love is:
content,
admiring,
abstract,
different,
even unique.

What is that totality?
Nothing is whole.

Each work to satisfy,
stimulate desire.

Page 48

Words
use
us.

Page 49

Love is a beautiful influence.
It is the blue sky of reason.

Page 50

Facts marry history
and plant the seeds of pathos.

Page 51

His love is broken
by desires of
power and praise.

Page 51

Truth is bullion
lost in the vaults of language.

Page 52

Material AND natural objects: How great!

Page 53

We are [metaphor].

Page 53

A metaphor is like the sun.

Page 54

There sits necessity:
love will purge sense.

Page 55

A New 'Us.'
We contemplate the significance of 'Us:'

Its solidarity,
Its inertia,
Its divisibility.

All these lessons
discipline our sensible arrangement.

Page 56

What annoyances,
inconveniences, dilemmas—
what reckonings of interest!

Debt and credit:

each
the fortune
of the other.

Page 57

Her emotions:
a universe
likely to be soon exhausted.

Page 58

Delicate persuasion
reduces the sensible to the spiritual.

Page 59

Sentiment is the azure sky
of stormy affection.

The endless variety of things
makes all things the same.

Page 60

There is not a universal truth, however absolute it is.

Page 61

Dumb idea: intercourse with a friend.

Page 61

It appears
That I have found myself!!!!

Unfortunately defective,
nevertheless pleasant:
like adolescent intercourse.

Page 62

He is sweet,
And my soul is yawning.

Page 63

Like a ship to be tossed
we are afloat.

Page 64

Wonderful culture—
emancipate us,
please us,
amuse us.

Page 65

The spectacle
arises a pleasure,
like a suspicion awakened.

Page 66

An unsettled fancy
steals upon the night.

Senses begin to chase ignorant thoughts.

Page 67

A disdain of nature
fastens
upon him.

Page 69

We age,
we learn,
we learn,
and the body is frail and weary.

Page 70

I love culture.

Page 71

Hot and passionate:
all the exercise.

We are helpless.

Page 71

Bad fortune—
it is a watcher more than
a doer.

Page 72

Idealism is
Idealism is
Idealism is

Useful.

Page 73

Love, inhale me
and my world.

Page 74

We do not understand
the discord of the world.

Page 74

We delight in empirical science
by addition or subtraction.

Page 75

Behold! A rich American.

Page 76

Symmetry, Oh mighty love!

Page 77

I distrust sympathy.

Page 78

He adores himself.
His selfish nature gleams.

Page 79

Enthusiasm lies broken and in heaps
because love is not yet extended.

Page 80

Affections unaffecting
beautiful bruteness
volatile obedient

A world for you, the phenomenon perfect.

Page 81

Your world. your mind: madhouses.
Snow banks melt.
Beautiful. warm. wise.
He is restored.

Edgar Allen Poe's *The Raven*

Sylvia Plath's *The Bee Meeting*

e e e e e e ee e e e e e

e e e e e e e ee

ee e ee e e e e

e e e ee e e

e e e e e

e e e e e e

e e e e e e e ee e e

e e e ee e e

e e ee

ee e ee e

e e e e e

e e

e e e

E e e e e e

e e ee e e e e

e e e e e e e e

e e e

e e e e e e e

e e e ee e ee e e

ee e

e e e e e

e e e e e

e

e ee e e e e e

e e e e e

e

e e e e

e e e e

ee e e

it almost broke my
heart too, he thought; and was overcome with his own
grief, which rose like a moon looked at from a terrace,
ghastly beautiful with light from the sunken day.

"I am in love, "

but in her heart she felt, all the same; he is in love. He has that, she felt; he is in love.

 as
if he had set light to a grey pellet on a plate and there
had risen up a lovely tree in the brisk sea-salted air of
their intimacy

 —their exquisite

intimacy

he had, especially in the evening, these
sudden thunder-claps of fear. He could not feel.

some-
thing failed him; he could not feel.

beauty was behind a pane of
glass.

this brutal monster!

this hatred!

this feeling about her
and they never spoke of it

"I love you."

it was a miracle.

XO Sonnet

Xxoxxoxxoxxoxxoxxoxxoxxo,
Oxxooxxooxxooxxooxxo,
Xxoxxoxxoxxoxxoxxoxxoxxo,
Oxxooxxooxxooxxooxxooxxooxxo,
Xoxoxoxoxoxoxoxox,
Ooooooooooooooooooo,
Xoxoxoxoxoxoxoxoxoxoxox,
Oooooooooooooooooooooooo,
Xxxoooxxxoooxxxoooxxxooo,
Xooxooxooxooxooxoo,
Xxxoooxxxooo,
Xooxooxooxooxoo,
Xxxxxxxxxxxxxxxxxxxx,
Xxxxxxxxxxxxxxxxxxxxxxxxxxxx.

Stephanie Brooks is a conceptual artist, writer, and designer living in Chicago. Her art has been included in national and international exhibitions in Berlin, Chicago, Denmark, London, Los Angeles, New York, Vienna, and Phoenix. She teaches sculpture and writing classes at The School of the Art Institute of Chicago, and is represented by Rhona Hoffman Gallery, Chicago, and Peter Blum Gallery, New York. She received her M.F.A. from the University of Illinois at Chicago, and B.F.A. from Ohio University.

www.stephaniebrooks.com

Rachel Furnari is a critic, curator, and Ph.D. candidate in Art History at the University of Chicago.

Kendra Paitz is Curator at University Galleries of Illinois State University and the curator of *Stephanie Brooks: Distance Intimacy.*

This book was published in conjunction with the exhibition *Stephanie Brooks: Distance Intimacy,* presented at University Galleries from February 24 through April 5, 2009.

ISBN 0-945558-40-6

illinois state university
university
galleries
college of fine arts

110 center for the visual arts
campus box 5600
normal, il 61790-5600
tel 309.438.5487
www.cfa.ilstu.edu
gallery@ilstu.edu

ILLINOIS STATE
UNIVERSITY

Illinois
ARTS
council
AN AGENCY OF
THE STATE OF ILLINOIS

This exhibition and publication have been supported in part by a grant from the Illinois Arts Council, a state agency.